INTRODUCTION

Who is YINYANG CAT? While of the feline persuasion, YINYANG CAT is a humorous, inspirational, and sometimes contemplative reflection of ourselves and the lives we lead. Inspired by the timeless Yin Yang symbol, YINYANG CAT represents the harmony between opposites such as light and dark, feminine and masculine, and positive and negative. In other words, he depicts our life's balancing act which requires both effort and letting go. Like all of us, he's just trying to make his way in the world. On occasion, he may exhibit "cattitude" because he has his bad days too.

YINYANG CAT isn't just for cat lovers. (Ok, it's obvious I'm one and can't help indulging myself in silly cat'pun'tifications.) YINYANG CAT can appeal to anyone who wants to laugh and ponder the sublime and sometimes funny journey we call life. I hope you enjoy the following visual quips and that they bring a smile to your face.

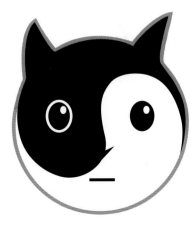

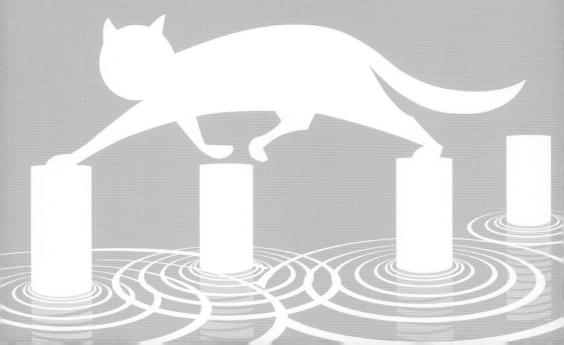

"RISE AND SHINE."

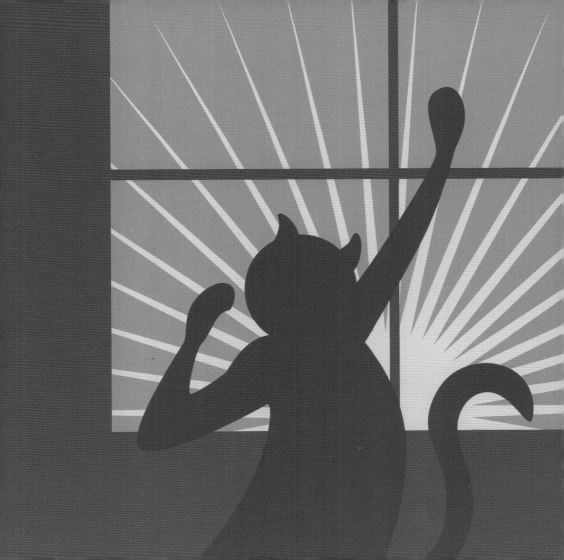

"GOT CATFFEINE?"

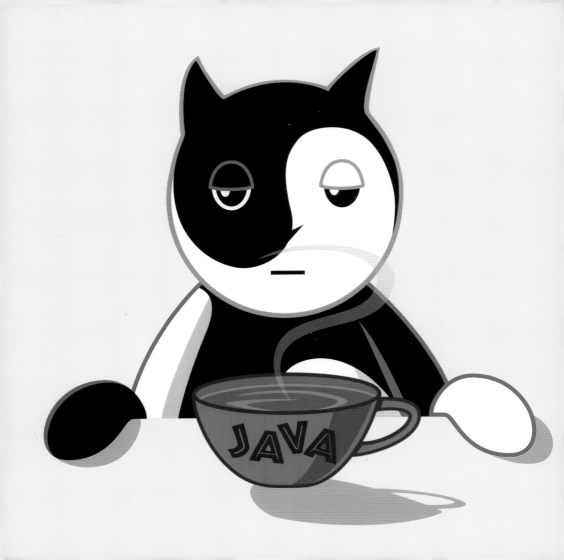

"i PURR,
THEREFORE, i AM."

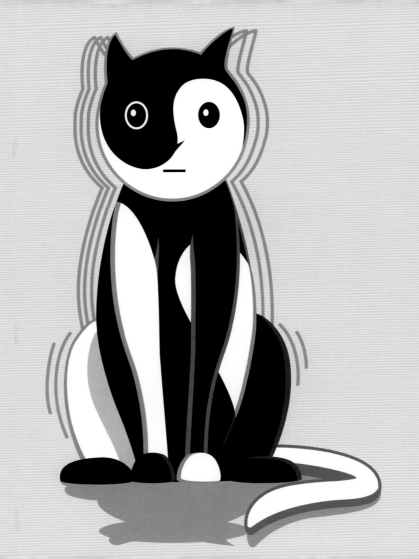

"WHEREVER YOU GO...

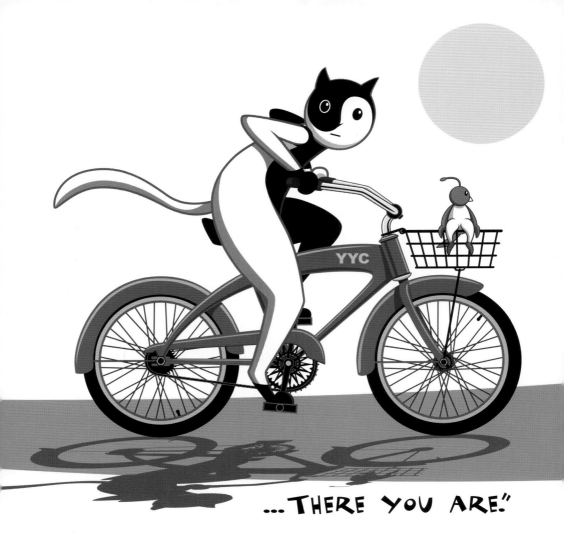

"...THERE YOU ARE."

"GO WITH THE FLOW."

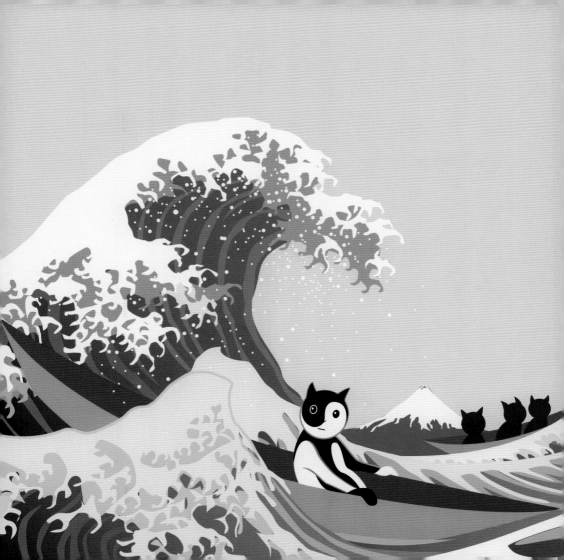

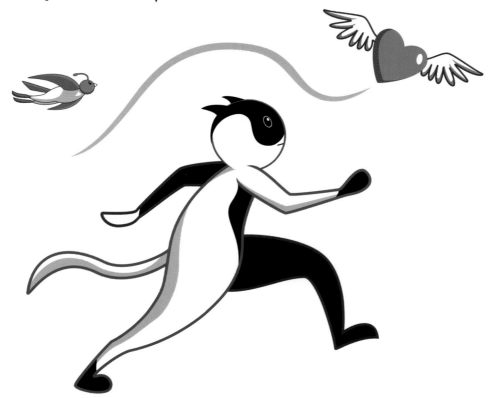

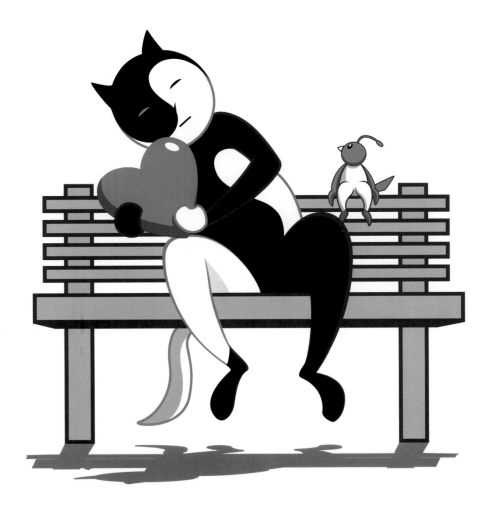

"CATWALK."

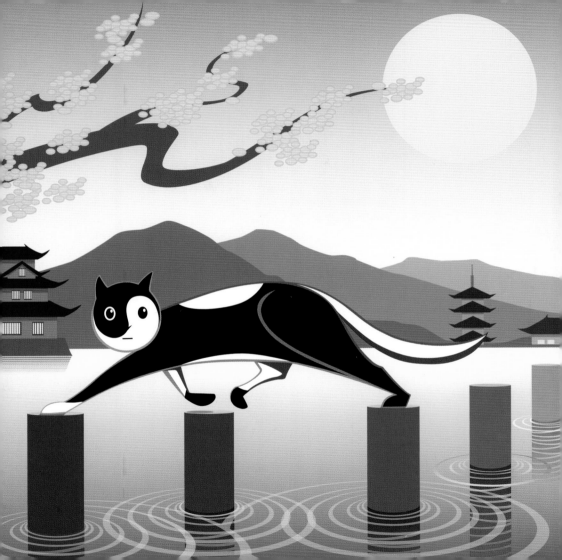

"LOOK ON THE BRIGHT SIDE."

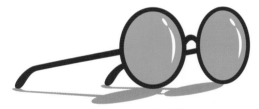

RECOMMENDED:
ROSE COLORED GLASSES

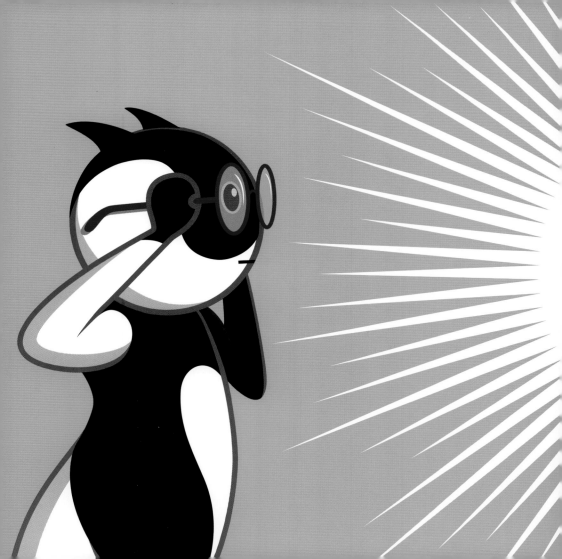

"PURRSISTENCE."

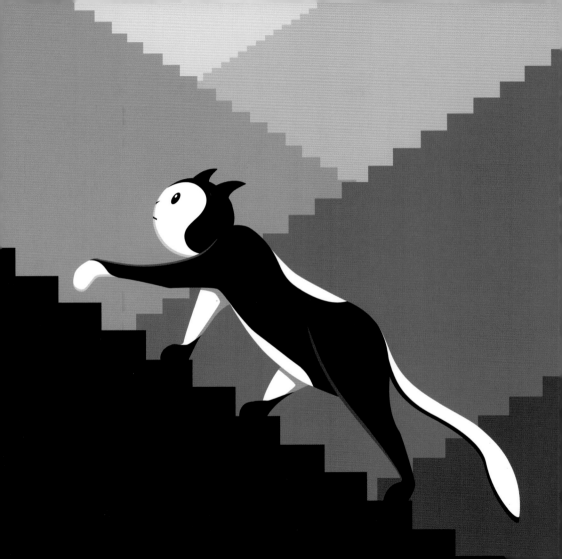

"THINK PAWSITIVE."

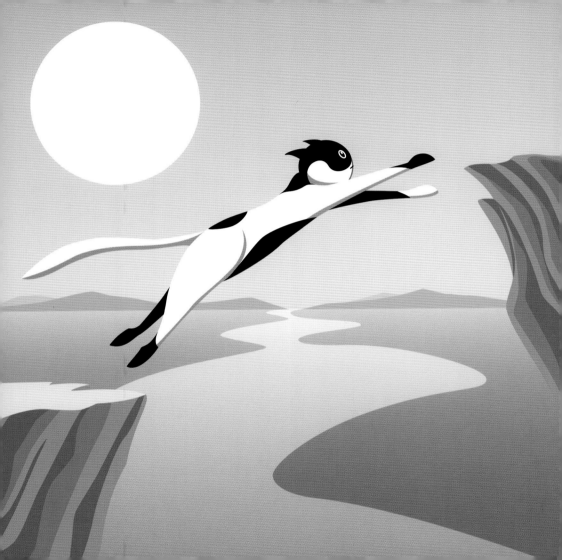

"MEOW i HELP YOU?"

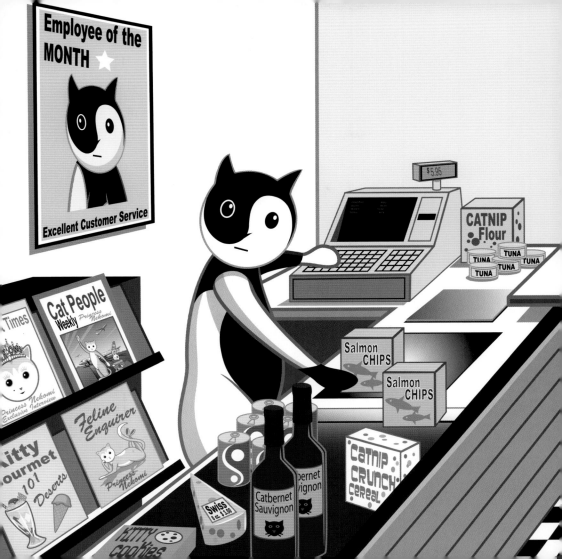

"STOP AND SMELL
THE FLOWERS."

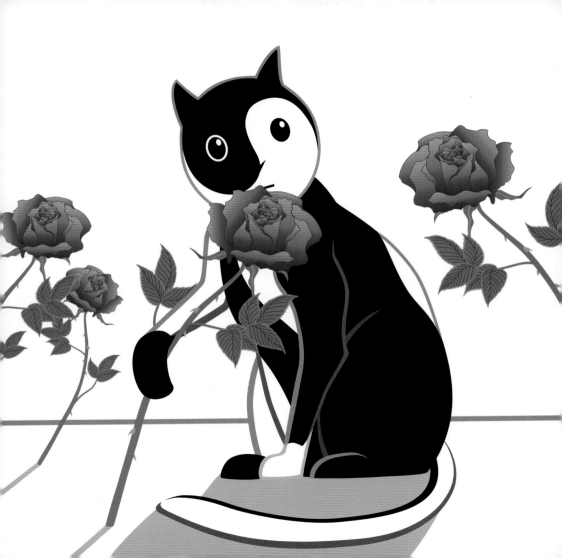

"PATiENCE."

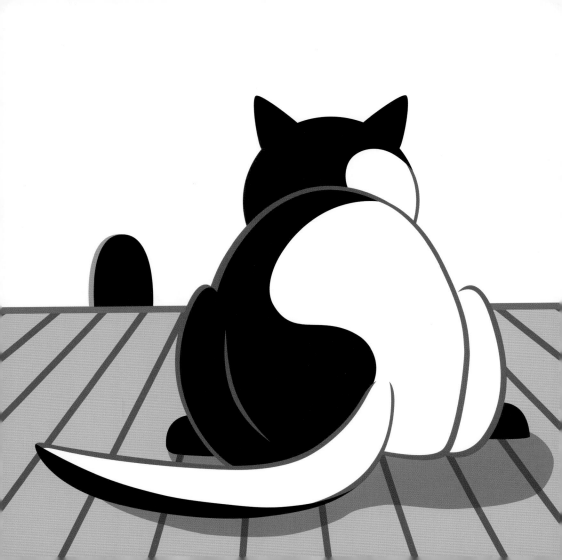

"CURIOSITY."

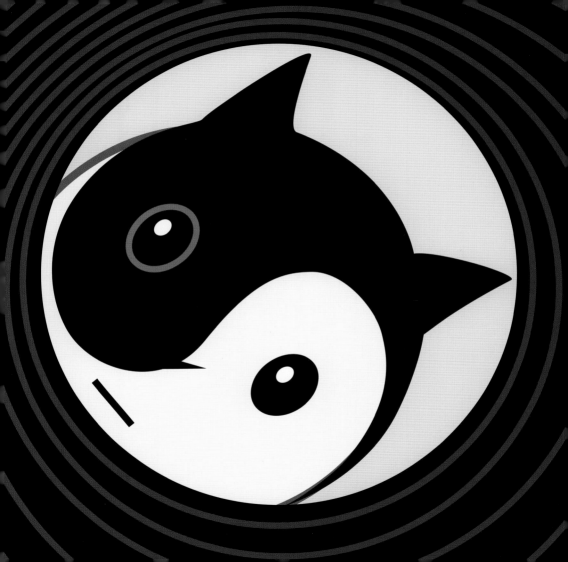

"PURRPLEXED."

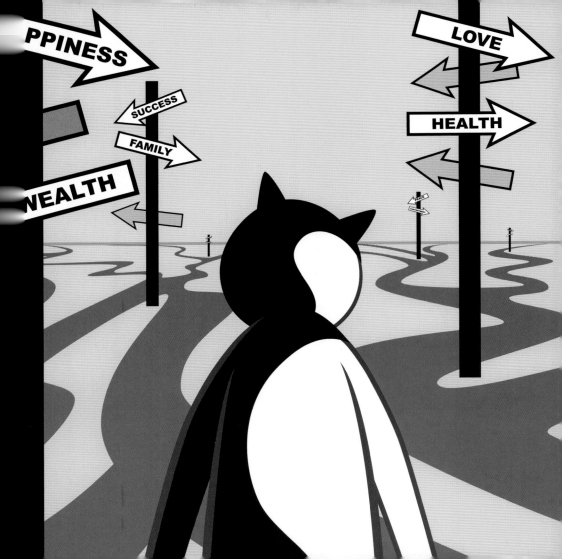

"REFLECT."

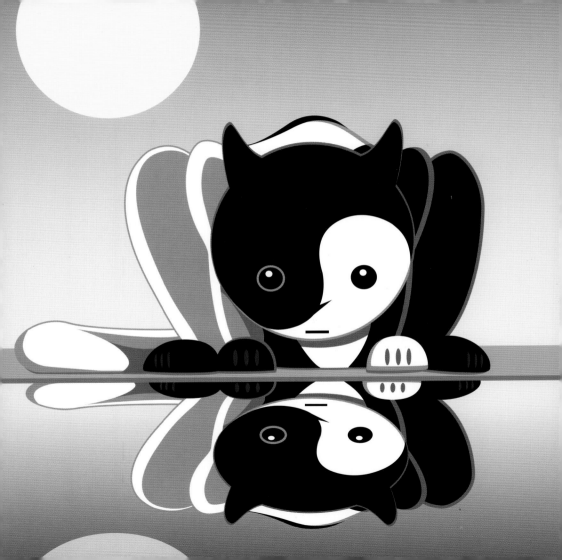

"PURRSPECTIVE."

"iT'S ALL ABOUT MEOW."

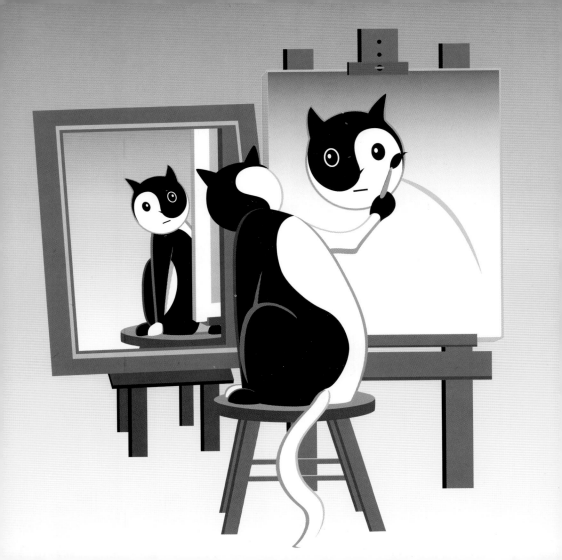

"CATOMIC."

"PURRFESSOR."

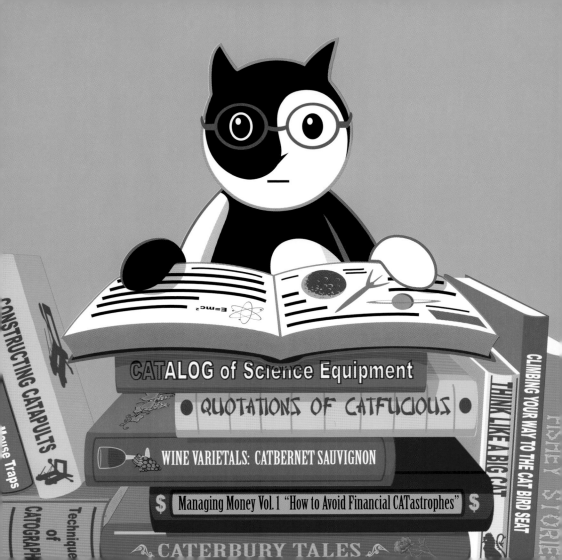

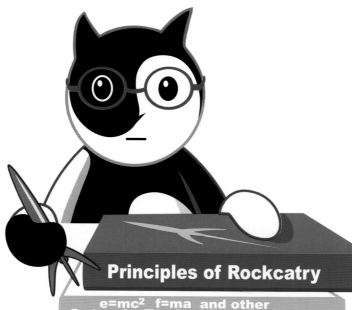

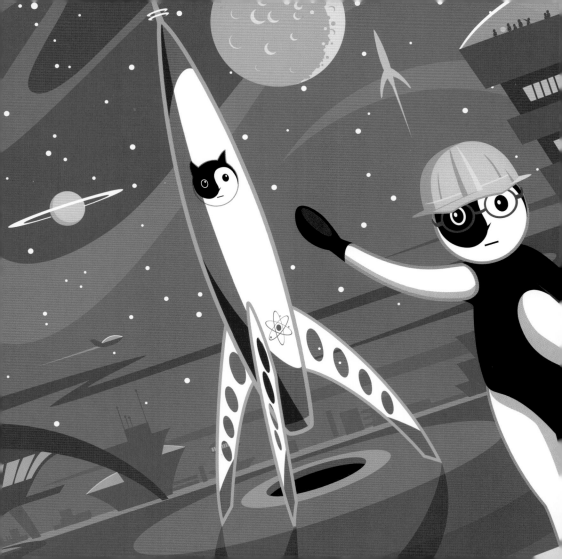

"CAT JUMPED
OVER THE MOON."

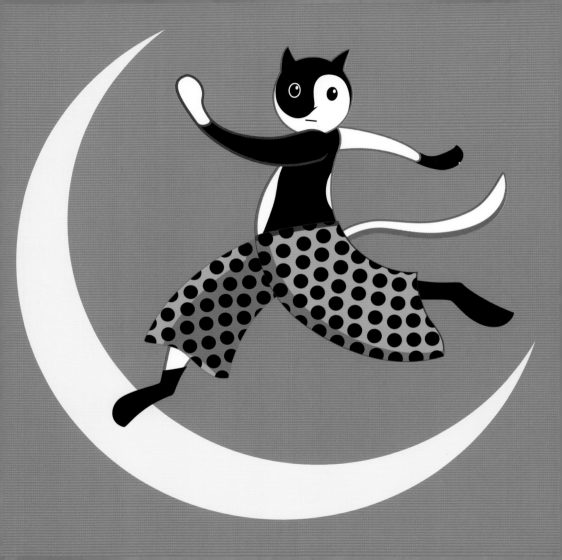

"GROUND CONTROL TO MAJOR TOMCAT."

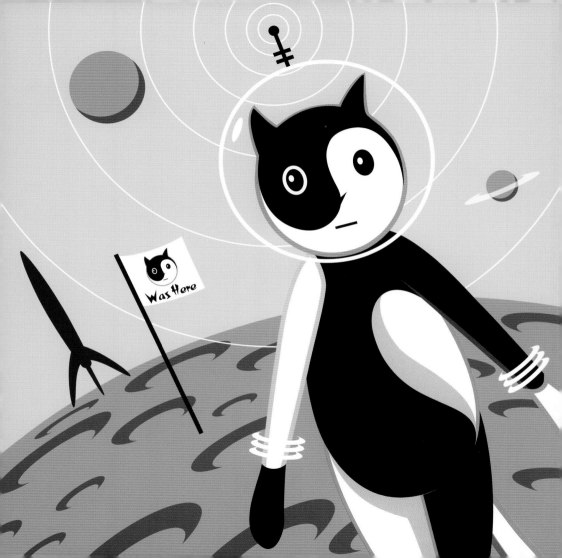

"CATCOPHONY."

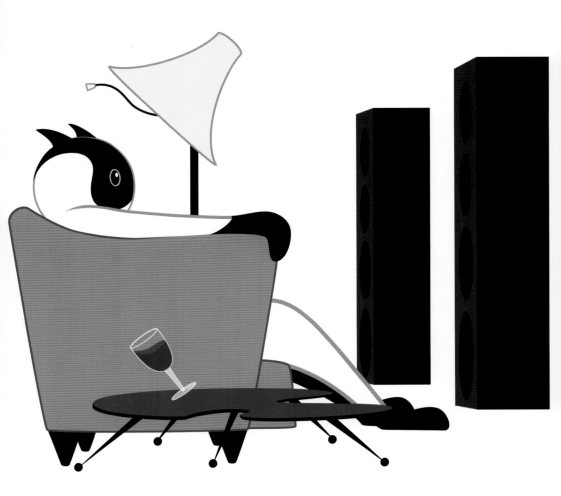

"iDANCE."

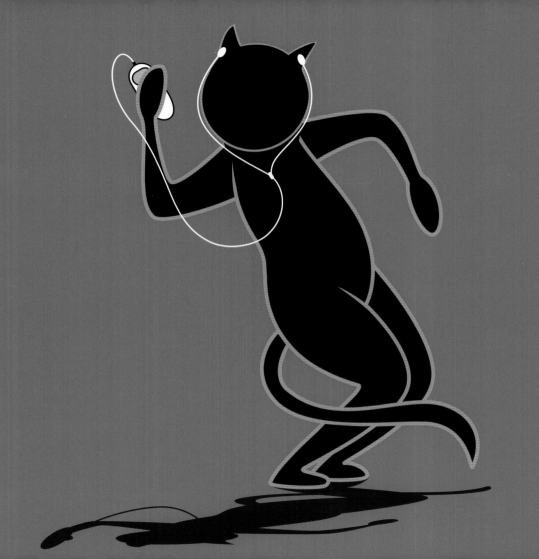

"CAT FOOD."

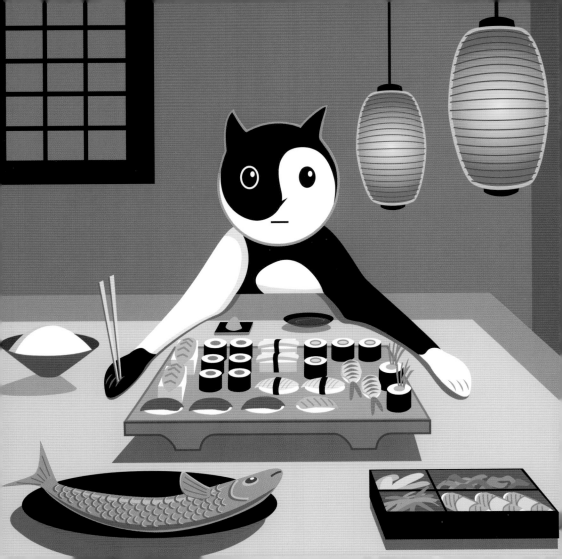

"PHAT CAT."

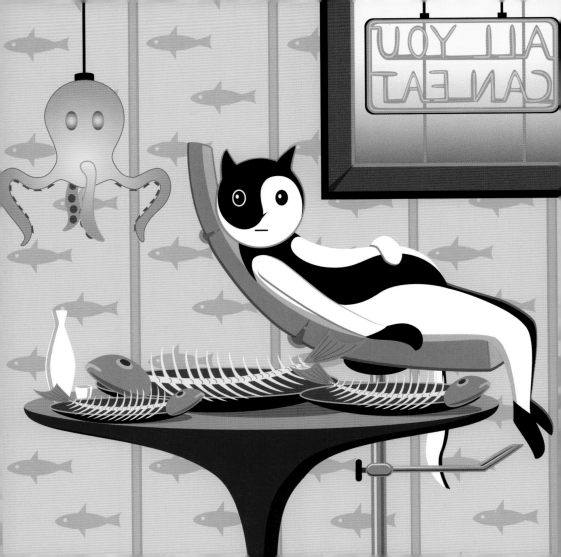

"CATACOMB."

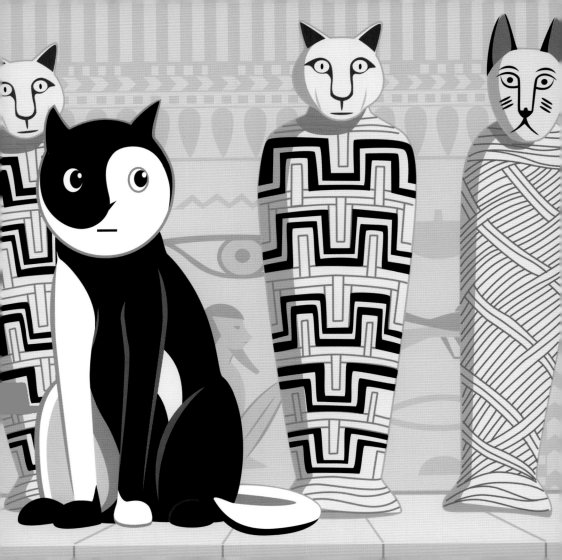

"CAT CRIB."

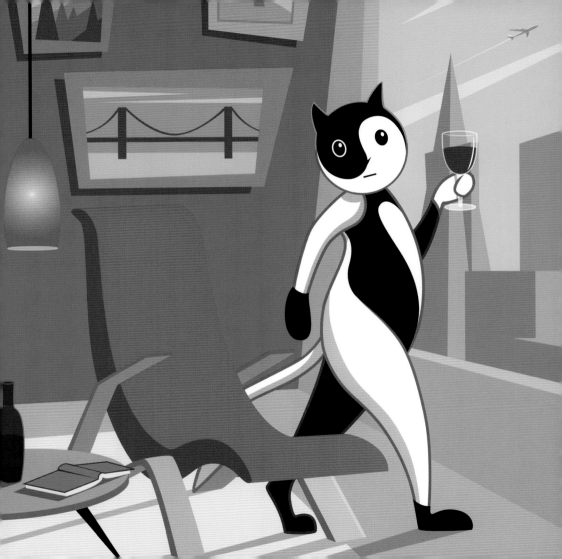

"CLAWS LINE."

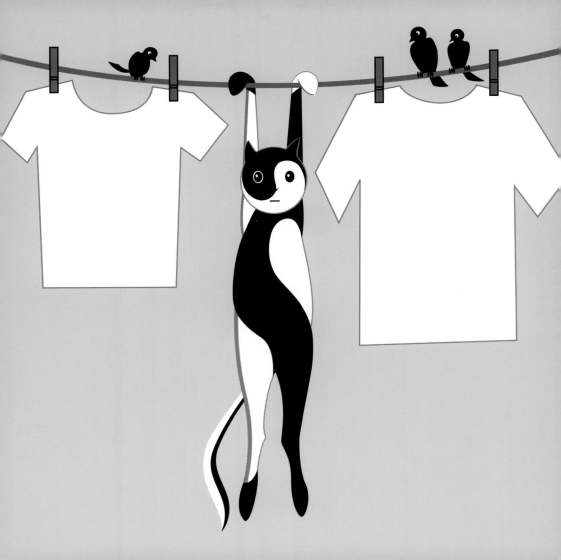

"CATNAP."

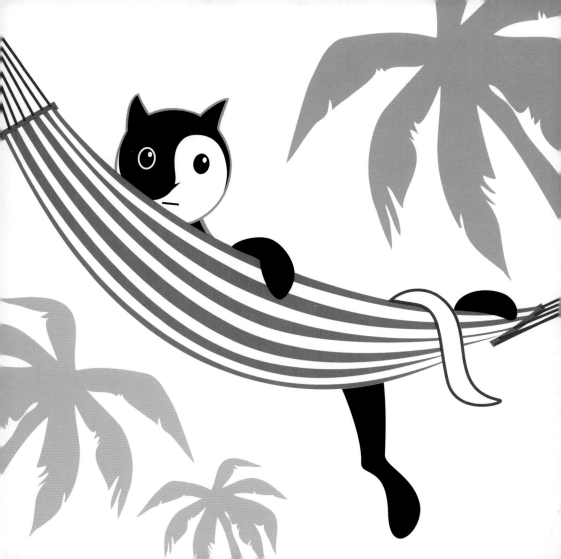

"GREEN THUMB."

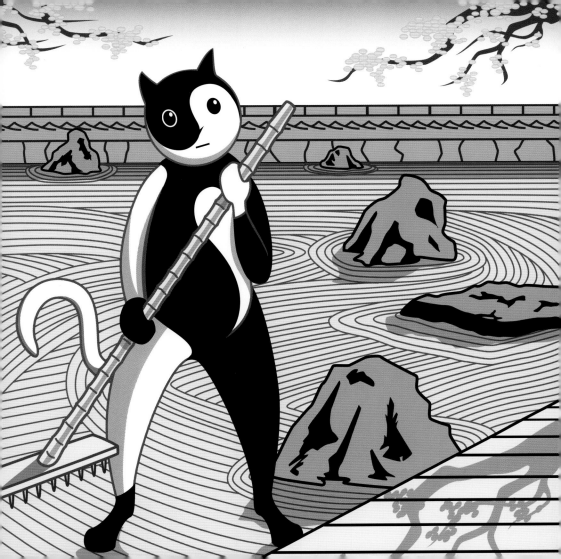

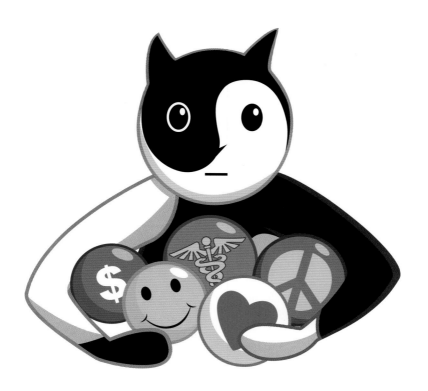

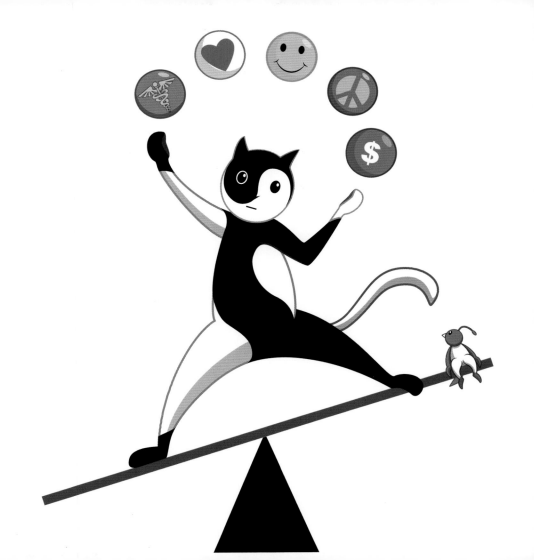

"Modern art."

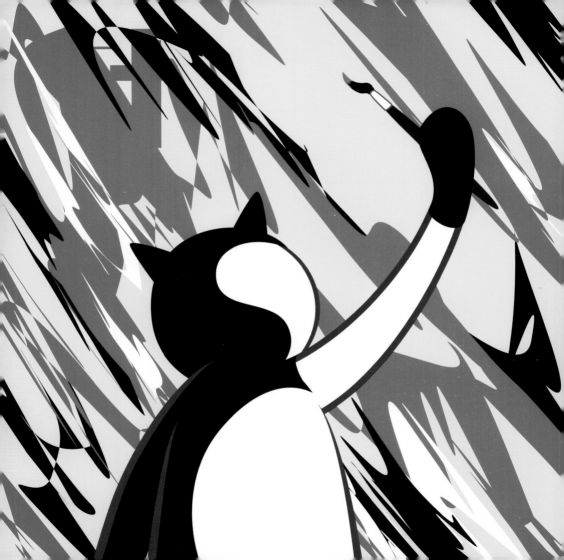

"WORK LIFE BALANCE."

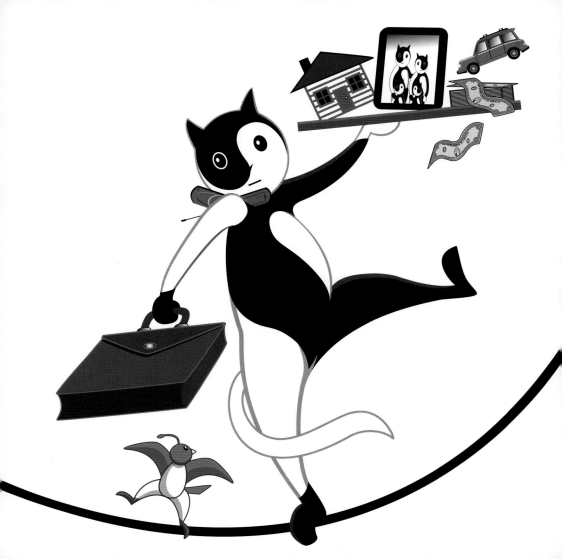

"CATSANOVA."

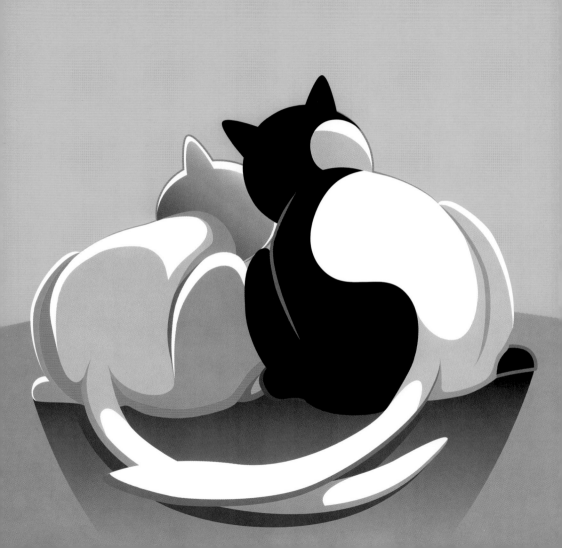

"FAMILY THAT PLAYS TOGETHER."

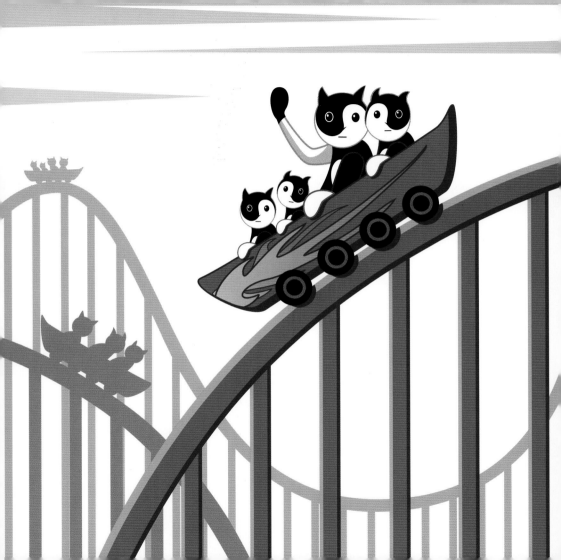

"CAT BURGLAR."

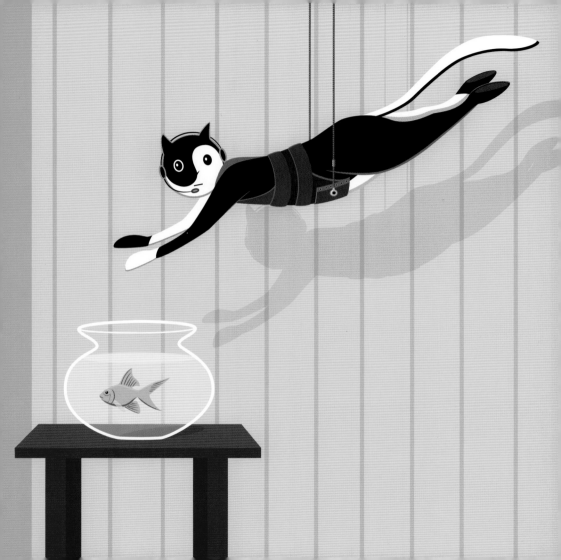

"BORN TO BE WILD."

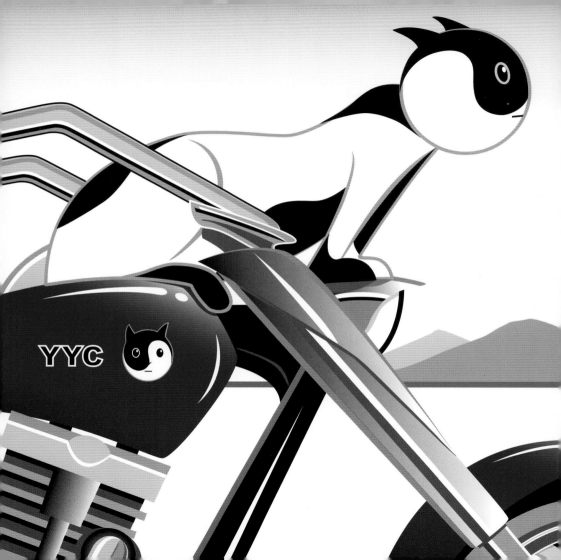

"TALK TO THE PAW."

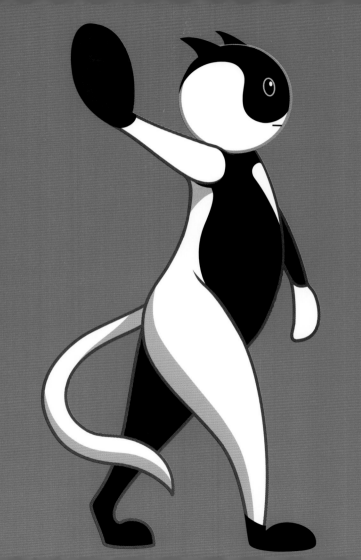

"NOT LISTENING."

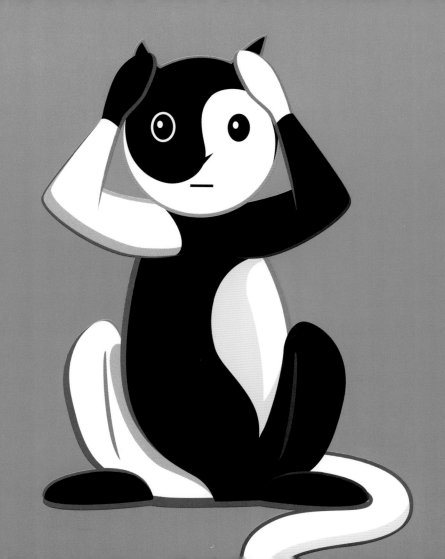

"CAN YOU HEAR MEOW?"

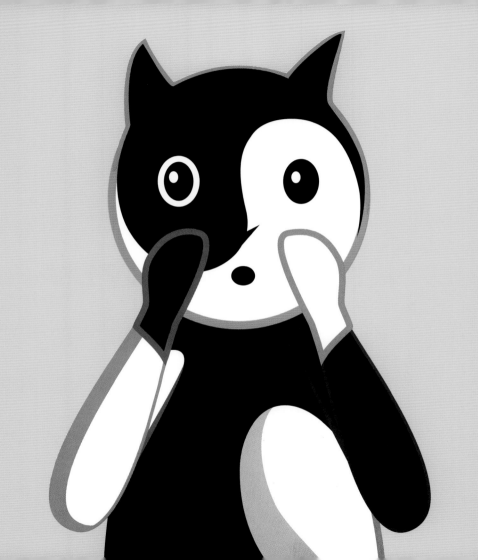

"i SEE MEAN PEOPLE."

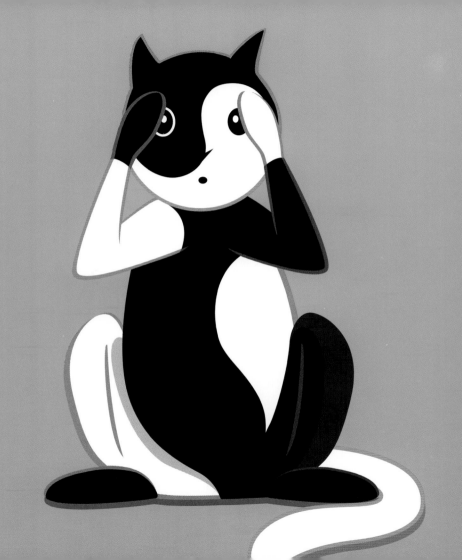

"i CARE. i JUST DON'T LOOK LIKE iT."

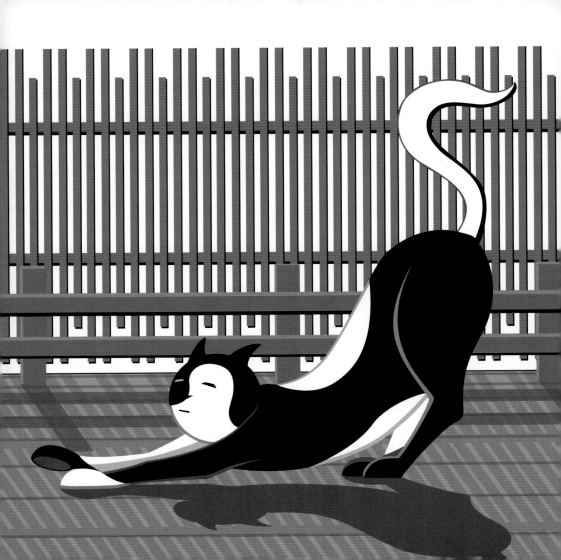

"CATTIRE: BLING."

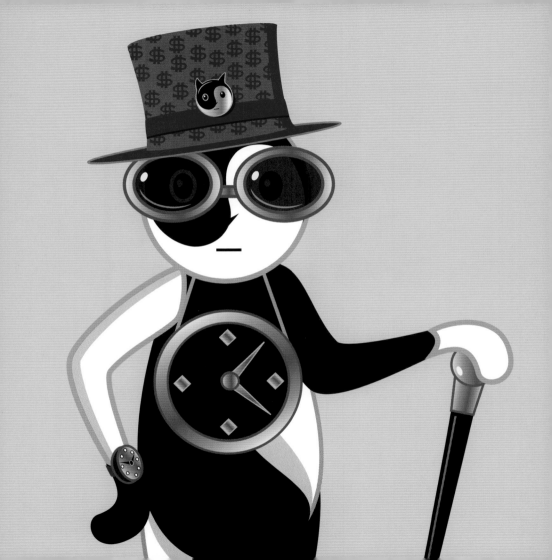

"CATTIRE: GOTH."

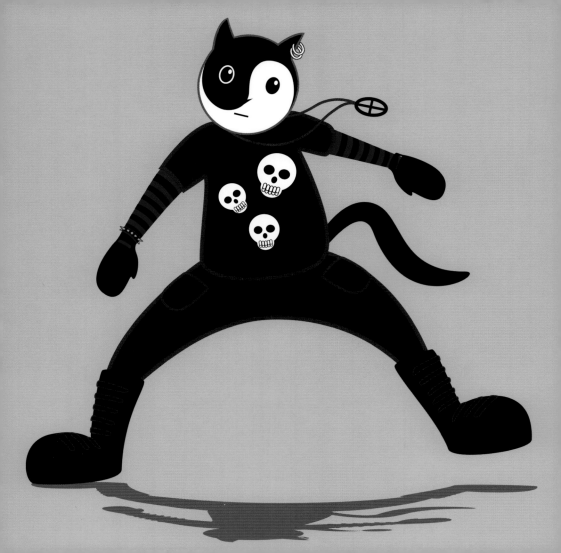

"KiTTY UP."

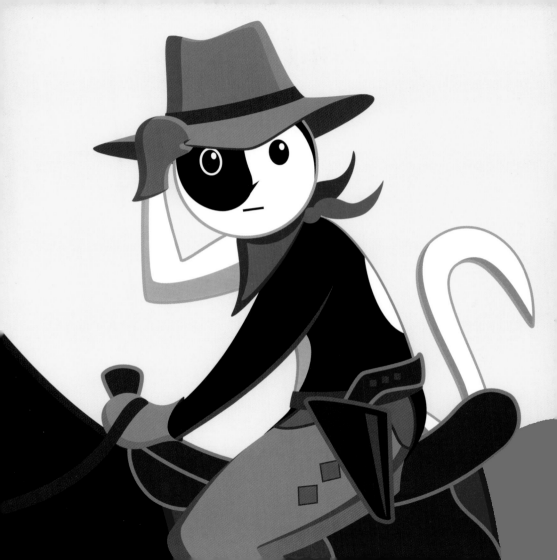

"MAW AND PAW."

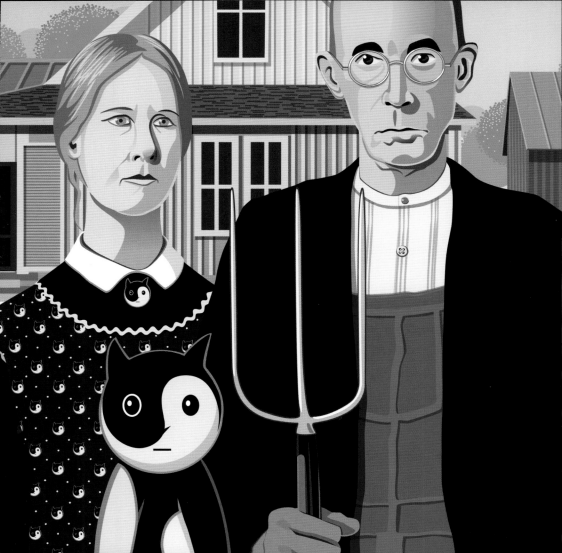

"CATBiRD SEAT."

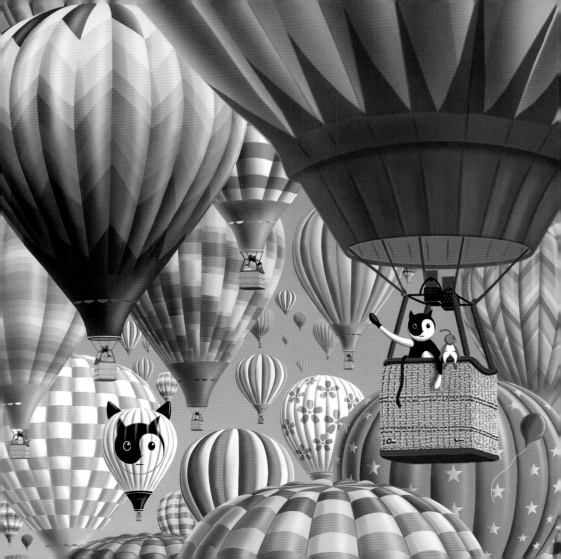

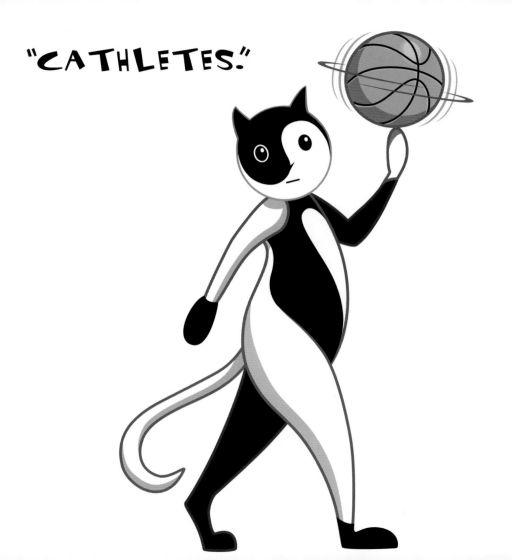

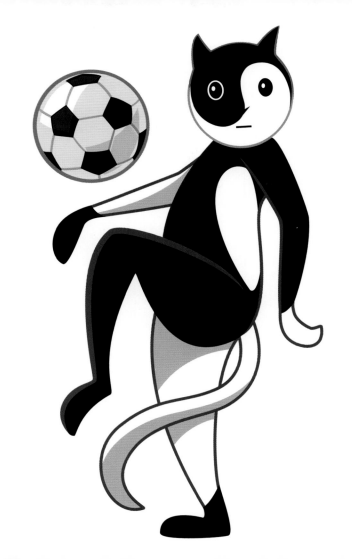

"COPYCATS."

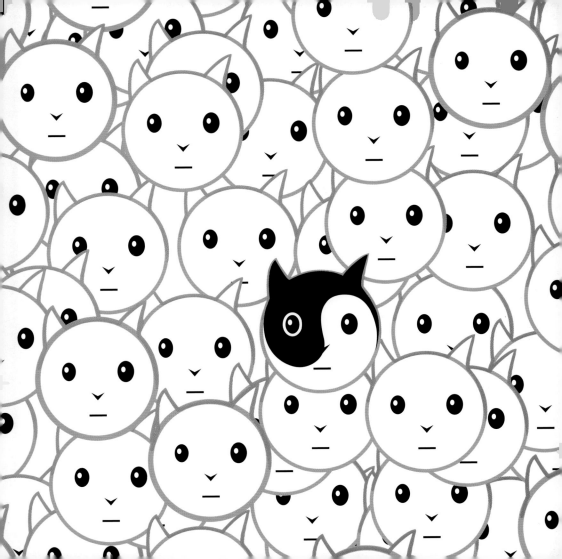

"CATHARSIS.
LIFE'S A SCREAM!"

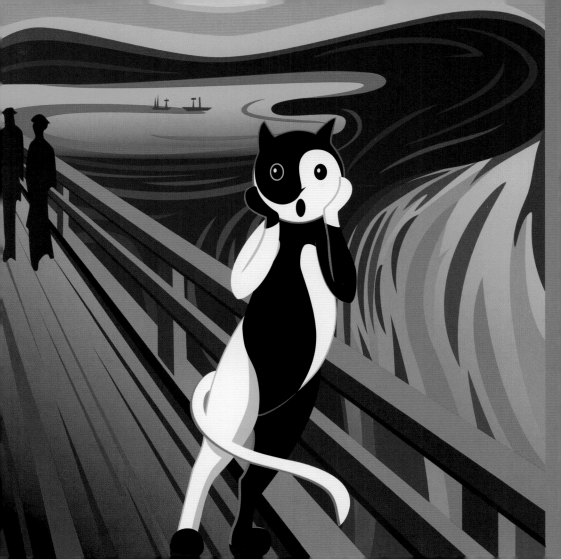

"ALONE TIME."

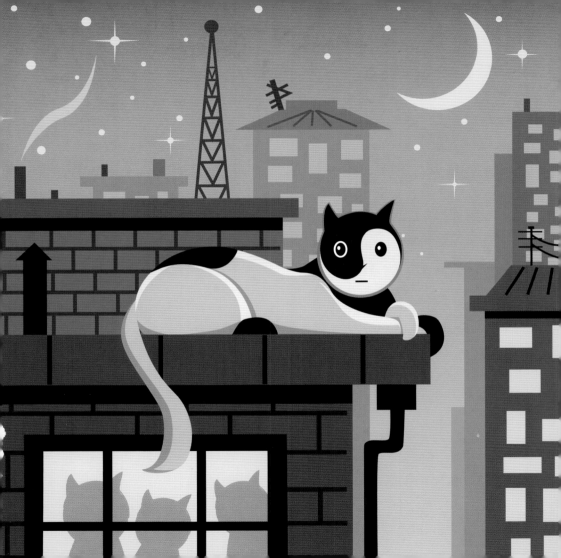

"AROMATHERAPY."

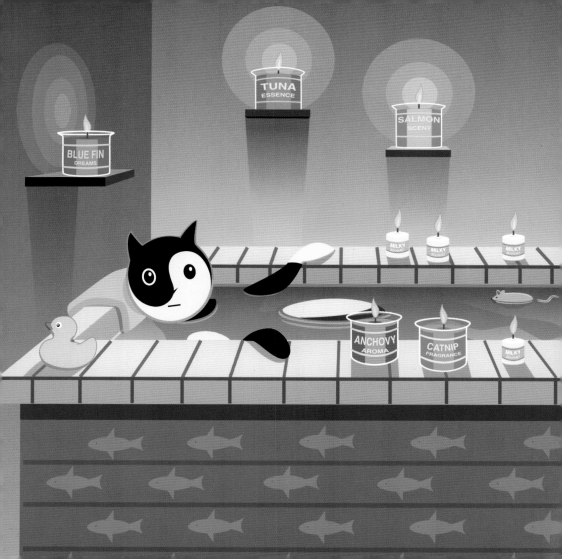

"CATEMPLATION."

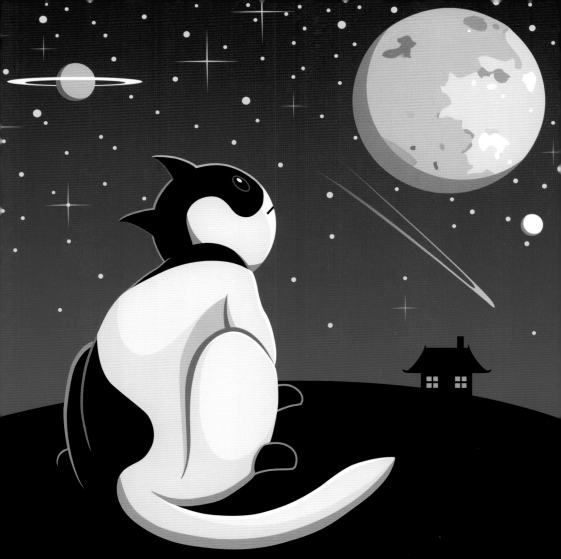

"CATATONIC."

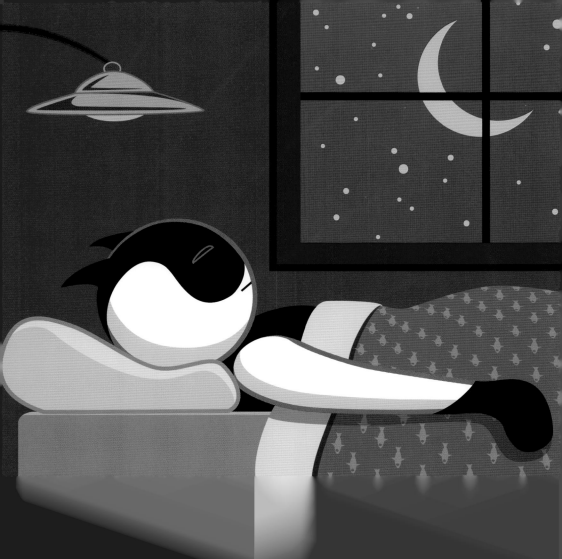

"TOMORROW IS ANOTHER DAY."

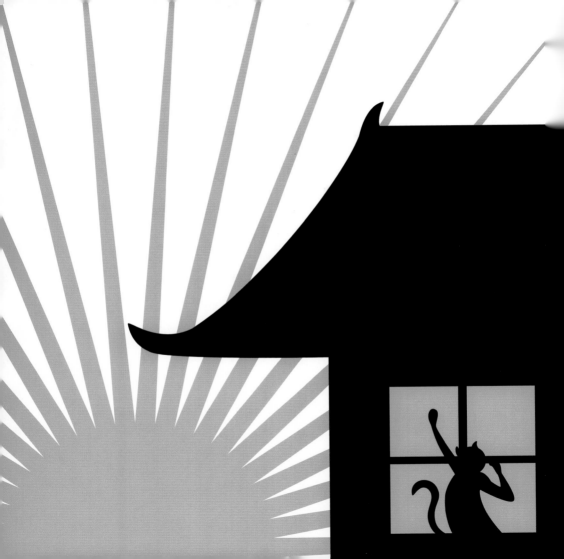

DEDICATION

WITH LOVE TO ARLENE, MY WIFE AND BEST FRIEND.

TO MY MOM AND DAD, TOSHI AND LEWIS WARD,
BROTHER AND SISTER, PATRICK AND CHRISTINE FOR BELIEVING IN ME.

AND, OF COURSE, MY TWO CATS CHELSEA AND UMA
WHO MAKE ME SMILE AND ARE MY SOURCE OF INSPIRATION.

Design by Jacqueline Domin, Global PSD design team
Printed and Bound in China by GlobalPSD

ISBN 1-59971-757-3

www.yinyangcat.com I **www.michaeldavidward.com** I **www.neomyth.com**

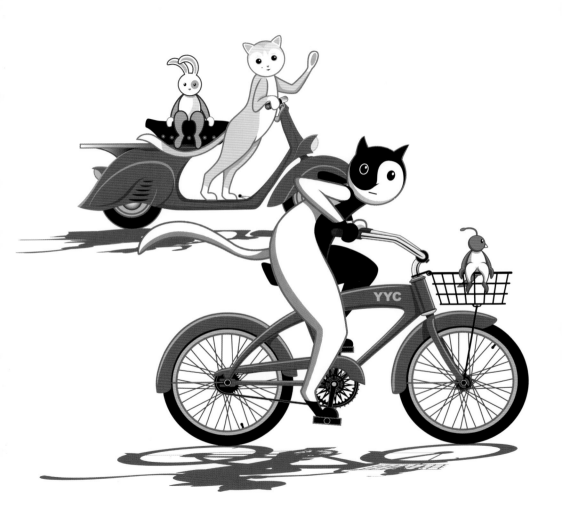

Look for another
Michael David Ward creation!

TENCAT™ ||||| |||||

Life is short and then you fly